IT BEGINS
WITH THE BODY

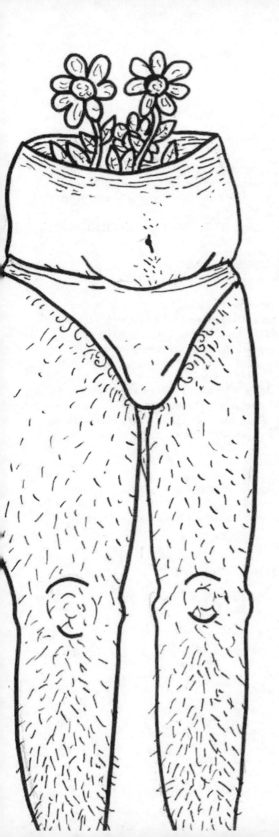

IT BEGINS WITH THE BODY

POEMS &
ILLUSTRATIONS

HANA SHAFI

BOOK*HUG 2018

 Canada Council Conseil des Arts
for the Arts du Canada

ONTARIO ARTS COUNCIL
CONSEIL DES ARTS DE L'ONTARIO
an Ontario government agency
un organisme du gouvernement de l'Ontario

The production of this book was made possible through the generous assistance of the Canada Council for the Arts and the Ontario Arts Council. Book*hug also acknowledges the support of the Government of Canada through the Canada Book Fund and the Government of Ontario through the Ontario Book Publishing Tax Credit and the Ontario Book Fund.

Book*hug acknowledges the land on which it operates. For thousands of years it has been the traditional land of the Huron-Wendat, the Seneca, and most recently, the Mississaugas of the Credit River. Today, this meeting place is still the home to many Indigenous people from across Turtle Island, and we are grateful to have the opportunity to work on this land.

Library and Archives Canada Cataloguing in Publication
Shafi, Hana, 1993-, author, illustrator

It begins with the body / poems & illustrations, Hana Shafi. -- First edition.

Issued in print and electronic formats.

ISBN 978-1-77166-443-1 (softcover).--ISBN 978-1-77166-444-8 (HTML).--

ISBN 978-1-77166-445-5 (PDF).--ISBN 978-1-77166-446-2 (Kindle)

I. Title.

PS8637.H345I83 2018 C811'.6 C2018-904017-3

C2018-904018-1

cover image by Hana Shafi
author photograph by Dylan van den Berge

PRINTED IN CANADA

To Mummy and Baba and Naz. Without you, there are no stories to tell.

To my best friends, who said every day I could do this, I could make it.

To every little brown girl with dreams so big the world can barely contain them.

CONTENTS

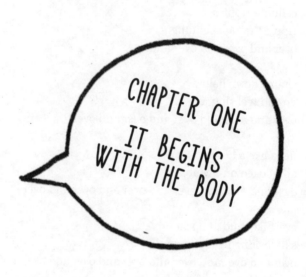

WHEN WILL IT BE OVER?

this body
hair like razors
razor on hair
over and over

blemishes like craters
craters in blemishes
over and over and over

cellulite ripples
ripple through cellulite
over and over and over and over

shame down below
down i feel shame
over and over and over and over and over

nose like a hook
all hooked on my nose
over and over and over and over and over and over

eyes like mud and salt
salt leaking from my eyes
over and over and over and over and over and over and over

this body never ends.

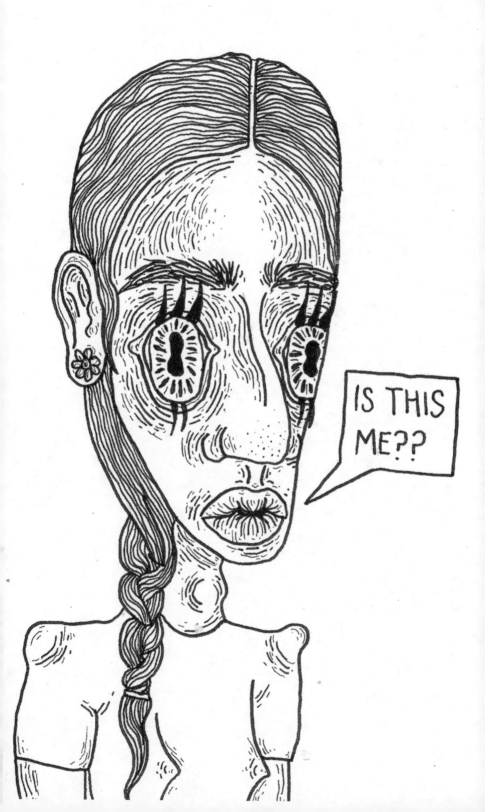

BODY TALK

cervix speculum vaccinate
lubricate trauma facade
shave moisturize bleed
wipe sting moisture
virgin whore irritation
leak discharge consistency
ovaries hair itch pick
stab touch burn fire
skin sick desire

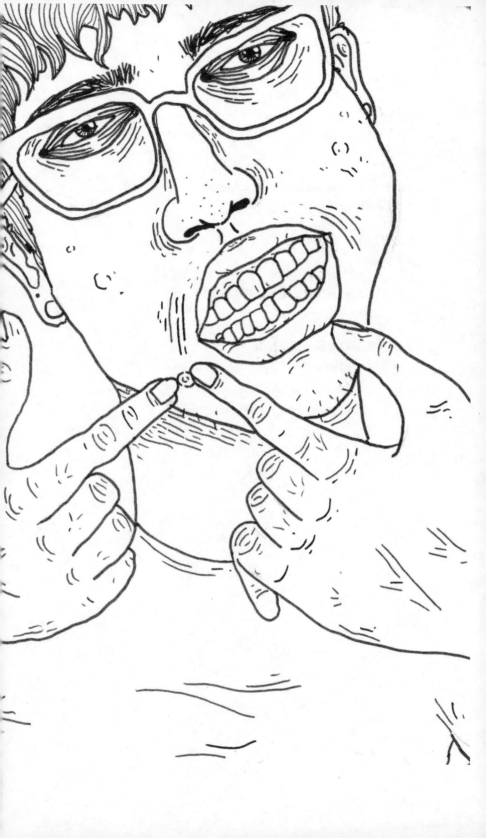

FENCES HE BUILT

and if i have barbed wire hair, it means no one
can touch me.

and if i have barbed wire hair, it means
no one will love me.

and if i have barbed wire hair, this body
is a prison.

and if i have barbed wire hair, i'll never be
a princess.

and if i have barbed wire hair
and if i have barbed wire hair.

ROMANTIC COMEDIES WITH A STRONG FEMALE LEAD

the chick flicks
got this one right
you could cut off your hair
and become

new
woman

i did it
started to wear long earrings
i want to look like an icon
even though i'm a nobody

but

he won't fall for
you the chick flicks
got this one wrong
everyone who ignored you before
will still ignore you if they hated you
before they'll hate you more

everybody hates a girl with a good haircut
even me
ugh i wish that stylish bitch
would just go away!

do i look cool
or like a loser with cool hair? the

chick flicks got no answer

STEP 1: HEAT WAX

STEP 2: APPLY TO LEG

STEP 3: PULL THE STRIP

STEP 4: LOOK AT THE HAIRY STRIP & CRY BECAUSE BEAUTY STANDARDS ARE CRUEL & UNJUST

24 YEARS

i saw a girl her
belly button bare
pierced and flat
cargo pants

like my favourite cartoon
you're perfect i'm grotesque
i don't even own cargo pants

she ate fries in a basket
made hops and barley
look like yellow gems

slouched on the couch
could i be lovely too?

men shook for her
the bar shook for her the fences
bent for her
the tab is paid for her they
ask if i smoke

but i'm so damn ugly
i should hope my lungs are
at least
half-decent

ESTEEMED

my chronic self-esteem issues
season my art well
tragically compelling
or just insufferably pathetic

that song by Offspring is my anthem
jagged baggy walk to work
a tired reflection in TTC window

pass out, it'll be just fine
get the good stuff
feel nice and sick
tell auntie so-and-so
"i'm well"
listen to grunge and wallow

i love to feel for myself
these are the times
to make misery look cool
and sing quietly
your favourite song

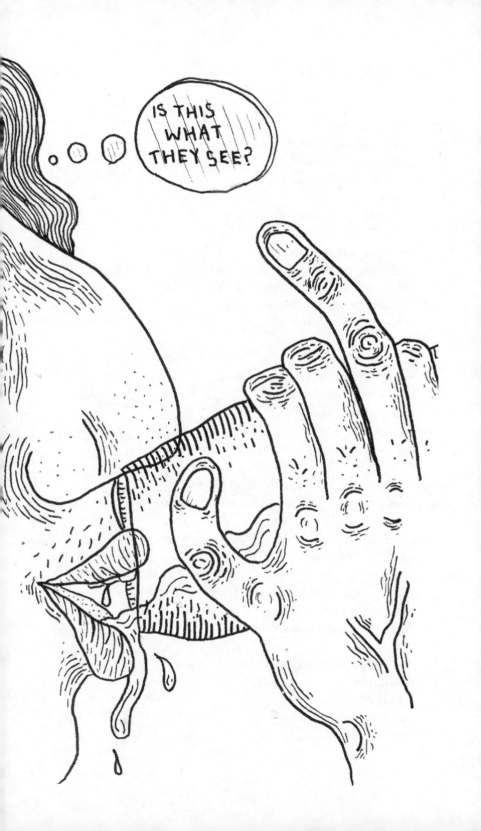

SEVERE WOMEN

who's gonna love us?
surely, you seek to touch
women with softer skin
white lilies on their thighs
pure milk
rolling off the mounds of their lips.

sweet princess who sways
in chiffon, just curtains in the breeze,
i remember every night that i've been
musky heavy drapes, dust-coated girl
at the back of the east-end party.

angular, rigid,
like the cliff's face, steep fall, a steep
 dialogue, i wish
 i was more gentle.
so i laughed more at jokes of men
but my laughter was brittle tree bark, my happiness
shrill, sharp,
i broke every silence like shards of plastic
party games, witty banter it's ruined i'm ruined.

i wanted to be
smooth jade and grass.
i wanted my voice to tumble out of my mouth like ivory sheets,
like girls with no acne on their back, girls without
chapped lips, i'm literally
flaking and crumbling all over you.

and my speech would smell
of lilac, but
i speak in tongues of ash,
cackling smoke crackling
skin.

who's gonna love us?
us severe women.
 who perch on steps like thunderstorms
who break the heat with a BOOM, who
try,
like martyrs to win devotion and instead
frighten...
us stone women, us women made of coal
and hard things.
rough earthbound girls, hardly darling, soil in my fingernails,
hairs on my fingers
ever so visible as i leaned over to shoot pool
in the least seductive manner imaginable.

us women of friction,
who bring tension, tough truth,
whose smiles cut water into sheets of ice,
whose breaths are the awakening shiver
to the back of the sleeping man,
for we can never, not ever
sleep shrouded in his ego, even if doing so
would make us loved.

who's gonna love us?
who's gonna love us?

i sweetly shout
into my pillow, my muffled night whisper
stolen clouds of feather, turning to gravel
beneath my cheek, i asked again:

who?

BLUE JEANS

jittery library footsteps
jittery at the party, jittery
fidgeter, i can't stay still
be still.

pick and listen
pick and mirror gaze
double-check my footsteps
my texts,
i
wish i wasn't here or that i was
in the body of someone else.

if i laugh, i wish i laughed lovelier
if i speak, i wish it was only song
if i touch, i wish my touch could be
like hazelnut coffee, or blue jeans or
spring queens or
 everything everything
a girl is supposed to be.

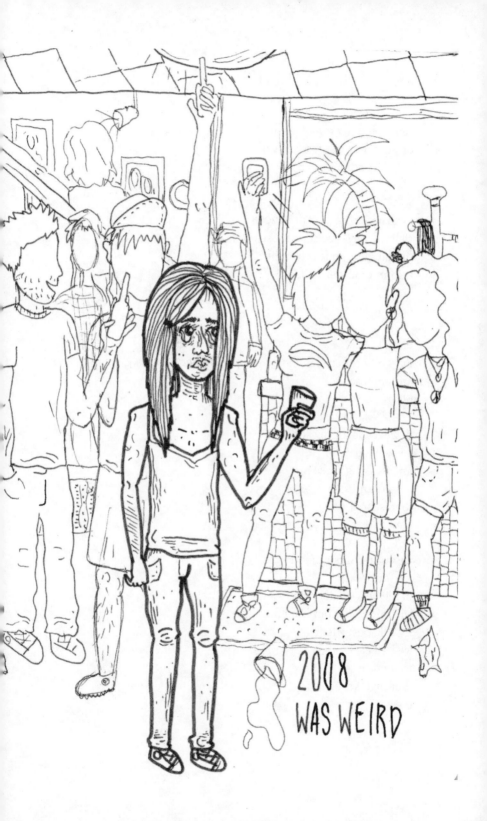

THIS IS OUR EDUCATION

remember the pink lockers
or were they mint? whatever
i can't recall high school
blew

i learned to be a bitch in 2008
richard's science class those boys
put laughter in this skin like
a splinter under nails

does she think she's hot?

i don't
i'm quite certain i'm the ugliest person here
and high school
blew

prank calls for my sweet 16
a special day for
an OK girl, thanks for
laughs and still
high school
blew

we wanted a boyfriend
for four years
made bets on doodles
wishing under our binders
it's OK, best friend
we had each other
to reminisce
that high school
blew

on the last day we left early
took the bus to the mall
without any goodbyes
thank fuck it's over
high school blew
see you at the reunion.

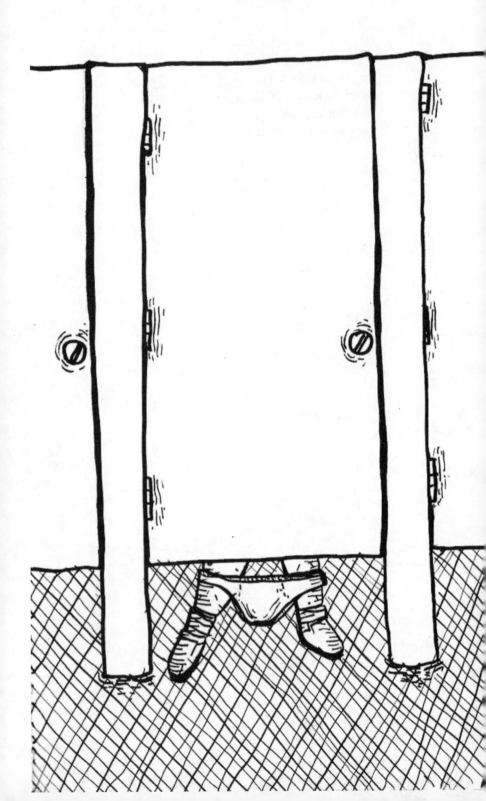

10-YEAR REUNION

At my high school reunion
i'll be a star
Jessica Rabbit of suburbia
unreal, outrageous and have animatronic breasts.
i'll be a space alien
a politician, fringe down the sides
of my pantsuit
i'll be a tragedy, a Juliet Ophelia to cry over
they'll throw daisies in my
cafeteria casket
i'll be an alchemist, anarchist
burn the textbooks, start a riot
a mural painted in my honour.
i'll show up with Kurt Cobain
he's not dead
he's my best friend
we'll spray-paint the principal
i'll wear a crown and a garbage bag
tampons for earrings
the popular girls will say it's trendy
then they'll wear
tampons for earrings.
i'll be a freak and a war hero
a pacifist, a Nobel Prize-winning
Victoria's Secret model
fabulous, unencumbered
with a rat on my shoulder.
i'll be a clinical
psychiatrist
wear diamond sneakers
and diagnose the former bullies.
i'll be Hana again, stage 10.0
the latest edition, newest release
queen of comebacks and loveliest corpse.
All in good time
10 years to be exact.

MY MOM LET ME
WAX OFF MY UNIBROW
BEFORE I STARTED
HIGHSCHOOL.

LINOLEUM

red rooms, bathrooms,
bathrooms,
stalls upon stalls,
the long bending hallway to my love-inducing vomit.

to my hatred
between nervous giggles
and back-handed compliments i
compromised myself.

hotel toilet, bar toilet,
loft toilet, east-side toilet,
north-end toilet, i'm always
fighting with myself
over linoleum.

hunched over hugged by fluorescence
i notice
with each stream of tainted urine,
i'm pissing myself away.

everything's clear now, everything's clear now, except
my heart, my faith,
murky as ever.

GRY/PCH

chemical serotonin
inhibitor inhibition
dropping refills
psych eval stomach
aches on flaking lips
spiral slightly through
hormones grandiose overtones
complex catastrophic case file
hard smile dial tones
call home shake shout
sensory overload twitch
shit impromptu vomit
too much too much
water pill sip
swallow—

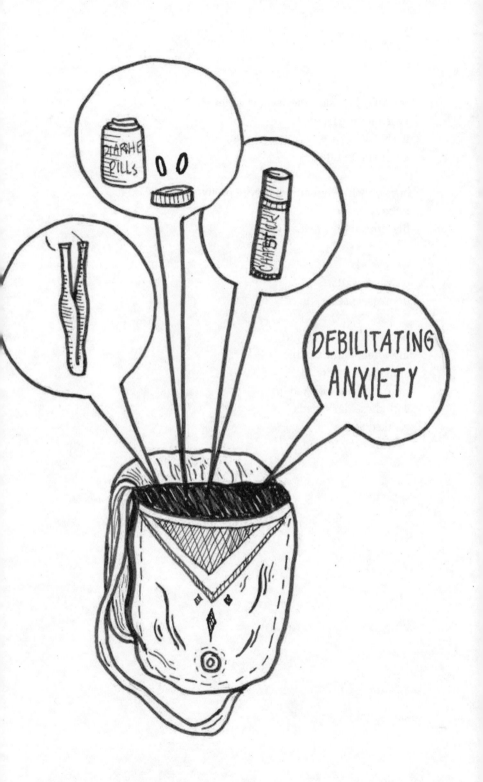

SAD N' UGLY

courtney love said the sky was violet
i wish it were true
it's black
and i am polluted

boys only like sad girls if they're pretty
nobody
likes the angry ones

wet eyelids
on white waifs
depressive aesthetic

boogers on a brown girl
me when i'm miserable.
sunken olive pits
were my eyes, i looked up
with these dark seeds
blinked to see
no violet sky for me.

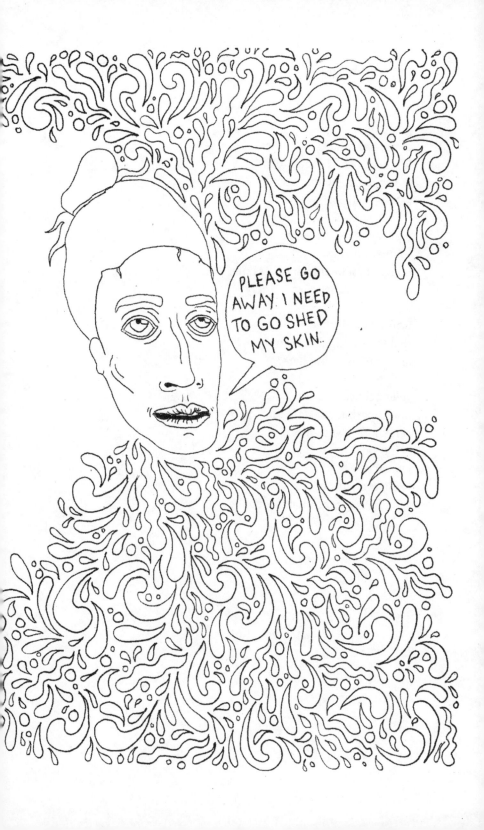

PLATFORM 24

green on black glass
at the train tracks
where cool kids contemplate
5-star red neon above me
a 3-star artist at best

a distant siren a distant
round of drinks
bought by a wealthy businessman
for a thin brunette

whose fault is it
that the spotlights in the sky
are everywhere but here?

yellow cubes each
open apartment i stare into
can i borrow your life?
is it good?
i swear
i ruin everything
with the hopes of what it could be

WEAR WITH STYLE WHAT KILLS YOU

i have knives in me
wrapped in velvet
dripping diamonds
gashes as
evening gowns
blood as bows
decorate the hurt

there are wounds
sewn up in lace
garters on my thighs
gauze in my lips
fingertips marred
by the skin it's touched

trauma
on my neck
like
perfume
lilacs and jasmine
oozing plasma
pearls draped
along my collarbone

these scars
are in season
guilt complexes
of the finest
cloth
chiffon and anxiety
terror twisted into
tulle

worn down

in my wearables
my infection
dotted
with crystals
and feather
couture till i
die

NERVOUS
STRANGE &
ICE COLD

*Must be 19 or older. Cry responsibly

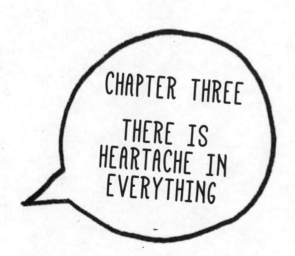

WHAT AM I SUPPOSED TO DO WITH ALL THIS STUFF?

all relationships in life
are just a collection of souvenirs.

if they last, treasured heirlooms.

and if they don't, just cheap knickknacks.
god, i have so many.

THE FRIEND BREAKUP

friend breakups are different. bit-
terness pools over clear waters, grief lasts longer,
hatred
creates cracks.
they spread everywhere.

it takes you from your base.
romance can go to shit,
but your friends are constant.
the part of the equation that is
 stable
known.
 necessary.

no matter how much you think you love someone,
you know in the back of your head that it could, can (maybe will)
break one day.
the nature of romance is risk.

it was never supposed to be risky with you.

friends never promise you love they can't deliver,
or promise to change and then don't change because i don't
want you to change, because you're my friend,
friends don't change.

the safety. the emergency kit.
if i lose my way, you will bring me back.
if i stray, you will find me.

perhaps i was your trusty fallback.

and if your fallback
falls out—

WHITE

white gaze
the podium, pedestal, mountain range
the desire of your blue eyes
makes me feel

 worthy.

white gaze
like a white malaise you've got me
stricken with a strain of delusion
that i am enhanced
under your watch and want.

white guys
make you smile, make me
hate
pluck wax squeeze
the pus out of the ingrown hair of my inner thighs.

white gaze
is he looking at me? what a rush
what a feeling what a
sickness.

VANILLA

Canadian boys
smell like vanilla and beer
coming off in waves
disdain in his smile, smiling
past headaches
hangovers

they leave
i didn't get to say goodbye
Canadian boys leave
trails of vanilla
across the province
sink their hands into city gravel
chuck pebbles
in their small hometown

they drink whisky
little chunks of
empty filling up in
the arms of Canadian
women Canadian
boys
like to say
"multicultural" but fear
brown girls

bugs in their brain
antlers break through their hearts
Canadian boys think
they are the elk they

are the hunter.

THE STRINGS ON THEIR WRIST

can you believe girls are
trained to be such
acrobats?

she dances
a marionette
husbands as puppet masters
jarring us back and forth and
back break twirl
collide

can you believe
the gymnastics we do
to justify his mediocrity?

can you believe?
we were
carefree curly things
before these strings

ENFP

i look for puzzles in people
hand under skin
rearranging pieces through
the front cortex

plunge fingers
into liver
to suck the alcohol out
detox your unpleasant
memories
chisel stress
from spinal chords
breathe the poison
out of lungs
sip fluids
slipping
 down
 the esophagus
you are cured
i ate your parasites

RED

i had barely eaten all day.
nauseated by nervousness,
nauseated by my happiness.

and i shook.
i shook the table when i laughed,
shook the booth when i clumsily bumped into it
on the way to the washroom when
my elbow slammed down too hard when
i squirmed and fidgeted desperate
to be quirky or
manic or
something that you're supposed to be.

i drank my drink in huge gulps
(when you weren't looking).
that was my only chance to hydrate otherwise
you might have seen my big
 big
 beak

nose
collide with the rim of the glass.
you probably saw it anyways.

and you said
out on the street, before the subway,
 you're different in person.

oh, i guess.

but i should've said no,

this is me.

CLOSURE

i heard about closure from a rom-com
searched for it ever since
is it getting a sweater back or
writing a letter
burning that letter
letting that letter
sit in drafts until
the wound closes.
is that closure?
people stop in the rain
knock on doorsteps
confess secrets at windows.
is your window at a good location?
people smoke cigarettes
they say "sorry
is that closure?"
people cry
they say "i don't regret
 i remember
i forget
what was it all about
what were we
 about
were we happy?
... i was sad."

is that
closure?

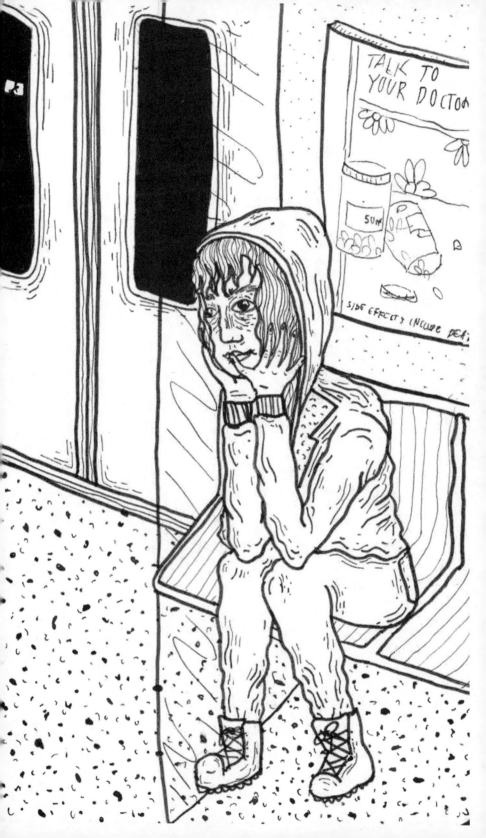

CHAPTER FOUR

THE MILLENNIAL RESUMÉ

AVOCADO TOAST

trampled to near death by wildebeests
at union station
the bruised and broken student
seeks out grassy plains
to make art
and be merry—

suddenly!
two jackals in impeccable suits
they lunge, cackling
"how will you ever save for a home!!"
the young artist sprints
through wheat and plastic
but she is no match.
she trips
on an avocado plant
the jackals tear away at
the youth's flesh
grinning
before dry cleaning
their bloodstained blazers.

as she lies bleeding, one last thought
before darkness takes her
"why!!! oh why!!!! didn't i open
a tax-free savings account??!"

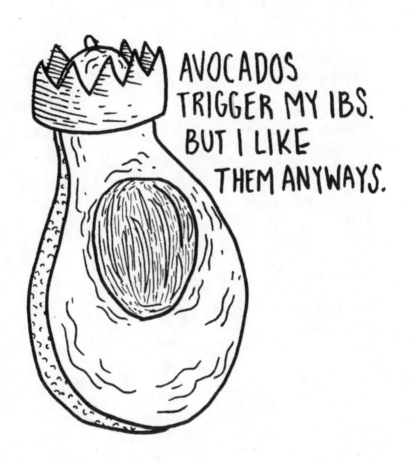

AVOCADOS
TRIGGER MY IBS.
BUT I LIKE
THEM ANYWAYS.

YOU'RE WELCOME

do the good work
i was told not everybody can
that i got to
rethink reframe new paths or
whiter name i wanted to do
good work.

i have four (current) resumés
folders of cover letters
folders of folders
of paper credentializing
alphabetizing quantifying
my right
to a life

i can do good work
but
"we have decided to not move forward with your application"
but
"it's not a good fit"
but
"we thank you for your application"
"we thank you."

A WAGE DEBATE

Minimum wage i've been told
i'll get a piece of paper, sometime in 2015
and it'll do nothing i'll be nothing.
Minimum wage some
 bougie twerp
 got mummy and daddy in
 high places, skyscrapers
filled with tie-wearing batteries
 top-notch big dogs with
less integrity than my asshole.

Minimum wage some
generic shit, eyes wide mouth
foaming with tides of complacency
lands a deal and a condo, a car
espresso-machine table from Ikea
suit from Hugo Boss girl with
shiny pupils who says things like
 "I love Indian culture," and he replies something
vaguely empathetic and i'm vomiting e v e r y w h e r e .

Minimum wage i've been told
i ought to travel to find myself says
white kid with dreads, hemp shoes, necklaces from Aritzia.
 Good one, kid, good one.
i've been told i ought to
see the world to become "enlightened" by the
mystical Orient, oh the charms the spices
that absolutely lovely
poverty.

Minimum wage my immigrant parents
are going to
weep

when i tell them
i still haven't got paid for my writing i'm not
as talented as they had hoped. Minimum wage
and paycheque and rejection and overqualified and
underqualified
and i've been told not to hate, but it makes you hate.

Minimum wage somewhere right now some well-tailored prick
is buying fancy sunglasses
and jerking off to *The Wolf of Wall Street*.

ECONOMICS 101:
THE
TRICKLE DOWN
THEORY

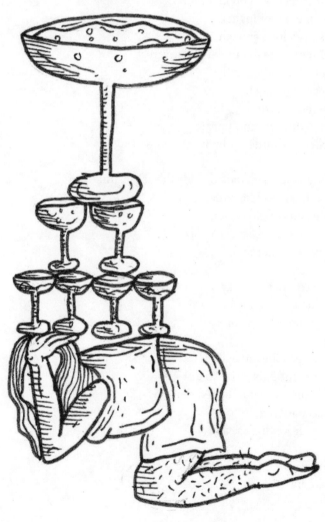

TORONTO IS TOO EXPENSIVE

i stayed long enough to see the park replaced
brand-new signs

a slide
without my name carved underneath
the house's windows got an upgrade
the screen won't pop off now
no more roof nights
i stayed long enough
to see the dealer under house arrest
get his freedom and
get caught again
to see dogs die
max the stray disappear
there is a white cat in his place now

they built a sidewalk outside the chain-link
but the gravel was fine
the empty field became
a pile of dirt became a plaza
with a restaurant

the tree in the backyard came down
something about a hazard
and our responsibility

i stayed long enough
to see the kids go off to uni
the cute guy with the red mustang
became a man
and drove that car away

the stream in the woodlot nearby
ran dry

a girl with pink hair walks her dog now
and i don't know her name
i used to know everybody's name

i love you all but
i stayed too long

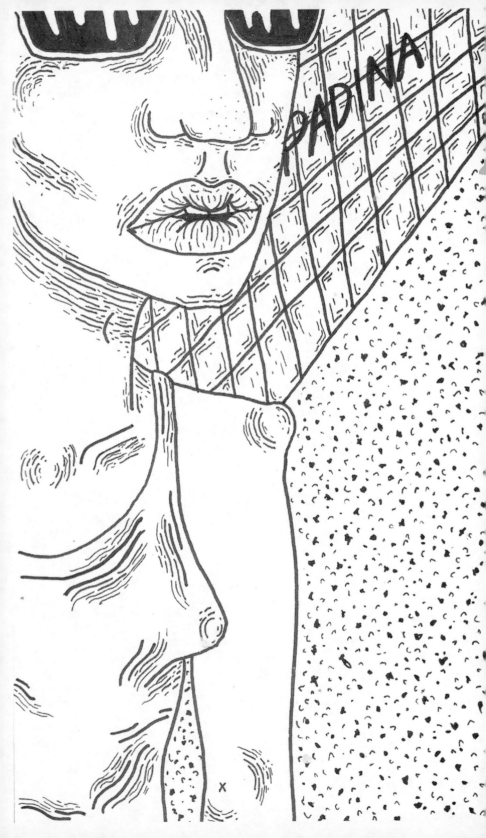

BAD BROWN GIRL

i can barely speak in my mother tongues stutter
my accent is bad
i hate jalebi
but i like aloo samosa

i'm a bad brown
girl i didn't join the
SAA or the ISA
i just didn't know
whether i was desi or irani
i said turmeric
before i said haldi
i go to white-people karaoke bars
i sang Nickelback with a tattooed man

i'm a bad brown girl
my family is from nowhere
and everywhere i'm not sure
i understand the meaning of the word
diaspora
but everyone keeps saying it

i'm a bad brown
girl i love my
culture
i hate my culture
i think my children *one day*
could be half white i worry
they'll never understand mama's life i worry
they'll understand completely
i'm a bad brown girl
i stopped attending Eid functions
i hear the community talk
do they like me?

do i like them?
i'm a bad brown girl
i rewatch *Devdas* with subtitles
i listen to qawwali but i haven't read
namaz in ages
goddammit i love everything
with pumpkin in it

i'm a bad brown girl
i worry i don't make enough
"brown girl art,"
but i'm a brown girl making art
isn't that enough?

i'm a bad brown
girl i could not be
your faux nostalgia of
the lost sounds of churiya
the winds whistling through the badghir i am
not sorry to be as i am
what the days made me
how the earth shaped me
neither a perfect sculpture
of the Orient nor the
postcard
on the success of assimilation

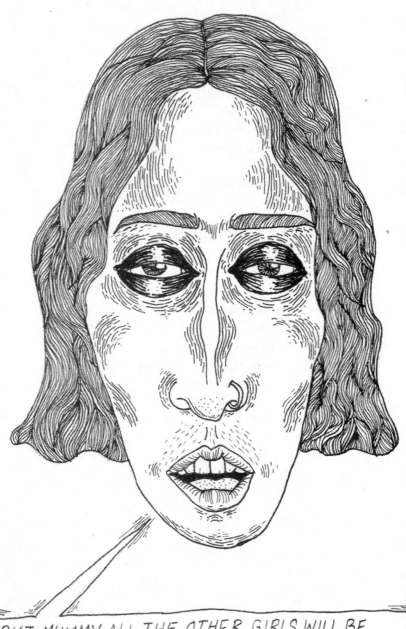

GOOD DAUGHTER

there are good daughters.
they wear shame as dresses
broken glass bangles
leave cuts that don't bleed
because good daughters don't bleed.

self-surveillance
weaving promises like
sacrifice compromise
maybe good daughters are
seamstresses and martyrs.

family is family is a
PR scandal
good daughters run damage control
and wear
light lip gloss floral button-up agreeable
clothing agreeable girls.

hands on knees
smile sip repeat
i glitch
ashamed to admit:
i have always wanted to be a good daughter.

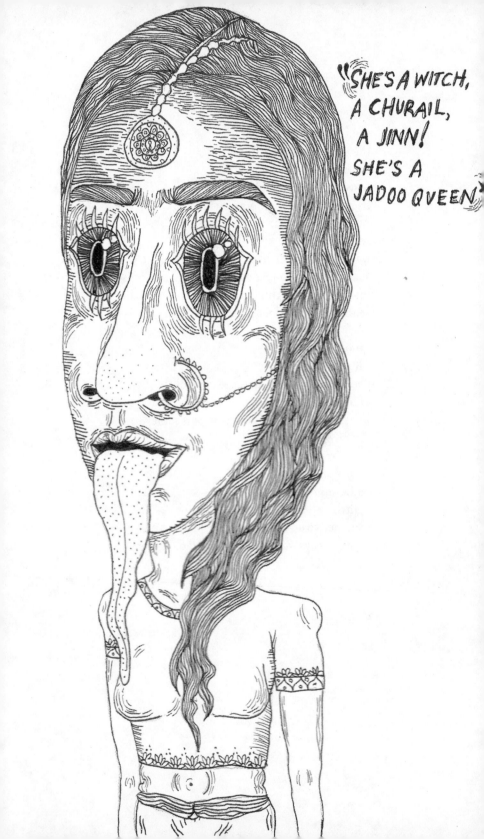

DON'T TELL

big sister tells a story
she's foolish she forgot
blood is different when you're brown

the stories surface
the house shakes
with shame and rage and
social standing with its legs kicked under

keep quiet
they said to me but
my blood
viscous with sisterhood
i give big sis the weed whacker
i tell her where the snakes are

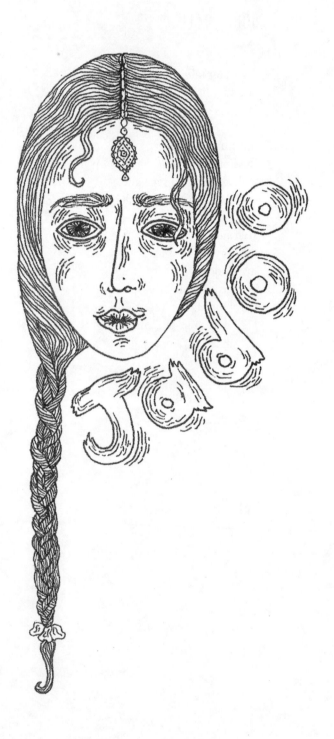

DL

double life queen
two outfits for her majesty
curated social media
only the best only the
purest most sincere
assalamu alaikum
from the double life queen
text set-ups mapping out
the venue best friends
come through
to celebrate the double life queen
create cover stories
scripts on scripts of premeditated
dialogues more convincing
than a famous monologue
double life queen, Eve
of her Eden harami temptress
a secret stain a blacklist
with 40 blocked family members she is everything master
of fate decider of destiny
rejector of sensible
ideas birth of
the virgin reborn
in the club
the campus
the 8th floor of the library
cheers
to the double life queen

THE FIRST PARTY

the lighting made my moustache
fifty times darker
my skin yellow

"are you going to A's
party?" Yeah, let me just
throw on two pounds of
blush
burn my hair to a crisp

i felt cute till i saw everyone else
epiphany i am
a spindly twig with AA
boobs and an ass pimple

"i'm so drunk!" she said
but i think she's just drinking ginger ale
and a drop of whisky

wild ones eh?
i held a cooler that i didn't even drink
felt solid as hell
it's me, a real-life Canadian teenager with an immigrant curfew

and hairy toes

BUT I LIKE MYSELF NOW

i hate myself because i'm not sure
do i only like being brown
now that it's trendy?

JINN

my aunt said the jinns were in the trees
at Maghrib *evening*
if you walked under the trees without saying
 BISMILLAH
the jinns would fall on you.

 Audhu Billahi mina-
 Shaitan-nir-Rajeem – Bismillah Ar
jinns can be bad, but some are good. *Rehman Ar Raheem*

 good jinns are not angels. angels do not have free
 will
 (and if i had no ability to choose, perhaps i would be an angel too)
my aunt said she has been followed by a jinn
he gave her a rose in bed.

i am not one of the believers
 but
i stare at the blue Maghrib silhouette of the branches
 and in my head recite BISMILLAH.

i think i might be a jinn
waiting in the trees
and with every *BISMILLAH*
i cast myself away.

FRIDAY CLASS

mrs. U said drawing was haram
she wore ballroom gloves
pearly white to hold the Book
during menstruation
her daughter yelled at Satan
muted TV music
cursed Halloween
spread the good word
all precautionary steps
before the day of judgment

mrs. U said
it could be anytime
ten years, tomorrow
next century
she kept us on our toes
speaking of threads
above bridges of fire
of angels
who ripped souls
out of feet

days
months
years
i stopped reading
i never wore white gloves
i drew every day

if there is a bridge so be it.

A FACE TO PRAY TO

i sometimes go to St. James Cathedral
hide in the pews
stare up at Jesus

i love the way He looks at me
forlorn in love
suffering in ceramic

gold leaves red shadows stained glass dancing
on the backs of worshippers whispers drop
like echoes and angels eyes cast downwards humbled
violent
divine

i love the way He looks at me
a certain blasphemy
a face to pray to
and i know, but they don't
that a Muslim is here

PROSTRATION

head upon
dusty carpet
we giggled
during sajdah

laughter left worship
sisters put your legs together
no gaps no spaces

i hated being a *sister*
who asked me
did i even want to be in *god's family?*

the call to prayer
bouncing echoes
under the dome
the call to prayer
fading out

sister adjust your shirt
i was told
you could speak to god
in prayer

dear god,
tell these women
to leave me alone

flip through the
book gold
along the spine
a holy ghost
told me
all families have their problems

THIS LITTLE BOY
STOLE MY CHOCOLATE BAR
AT THE MOSQUE.
I WAS NEVER THE SAME.

CHOCOLATE
Smooth & Sinful
30 grams

FAITH IS A RELATIONSHIP

my god speaks
sings rock operas
shrieks screams
across heaven's highways

my god is genderless
sends ghosts into my dreams
oh
my god, i've been haunted
for ages

my god is tender
violent and free
made amends
with the morning star
dances into twilight

my god hates worship
and dogma and
sunday school
sometimes my god hates me
sometimes we hate each other

my god is an absent parent
is a spectre
and a friend
i pray to my god
every now and then
my god answers.

CHAPTER SEVEN

IS HEALING
REAL?

DESIGNATED BITTER TIME SLOT

i write a message to copy paste to my friends,
as repeating your aches, personal failures
puts a strain on your thumbs.

UV ray
you and me today
blue light cellphone screens
casting some unknown theoretical health defect
or whatever into the every message of pity
every message of sympathy
every message *"i'm sorry * MILD FROWN EMOJI **
 (but at least,
 but at least,
 it's not happening to me)."

in my current state i imagine
that everyone is secretly terrible,
love is useless, friends are reckless,
family is senseless, and isolation is the key
to prosperity

but

in a few days, i will wake up
some party to distract myself and remember
that
people are good,
but let me have this moment to be a petty bitch.

THE DOLL I WAS

i was supposed to be a punk rocker a
smoker and a bartender
framed under blue lights street
lamps half-shaven heads

i would've looked good as a smoker
i was gonna have an apartment
living above a bar the
music, melodic shaking the floors
walls vibrating the scent
of liquor reverberating
in cerebral pulses

i mutilated my doll in the 7th grade
gave her piercings with
sewing needles
tattoos in permanent markers
a purple streak in her hair
my idol stuffed with cotton
my hero sewn in fabric
my truest self

the keys would jangle
in the door, flecked paint
falling in chips on old leather
boots stiletto pumps a cocktail
dress and other concoctions
cheap spells and metal music
watching violent blockbusters
before my nights out

i'd try every medium mode and method on the floor
in black socks with holes
swallowed whole in grey plumes
decorating the ceiling

in a cancerous dance

before it all
 swirled

 away
just another dream
when i was a punk rocker

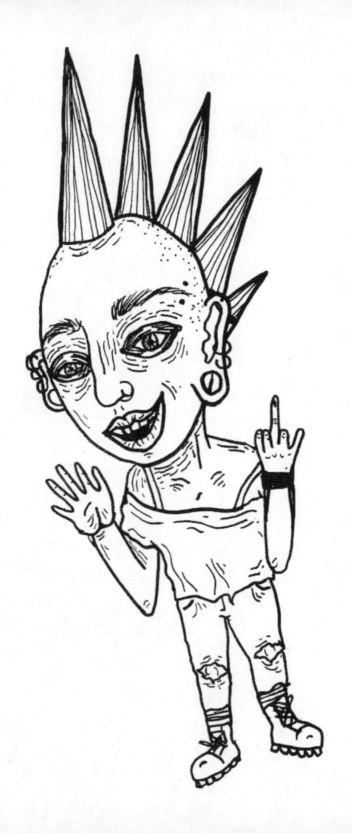

HOW I LEARNED TO FORGIVE AND KEEP LIVING

used to have the sun inside me
burning light, acid
through bone and muscle

each day
a long long raging fire
so badly
i wanted waves
to put out the flame
fill my lungs with an ocean

i thought i needed the sun
despite third-degree
scars it was keeping me
alive
you can't get rid of that

i thought sulfur
was passion
eyes of ash and disaster
keeping the heat high

but the cycle came in
commanded tides
a biblical flood rushing
the sea into my stomach
streams into the seams of
my veins, eyes
and teeth

i cast the sun out
invited the moon inside
to begin its harvest
in my most heated burns

RITUAL

i stayed up all night writing poetry
drank my sadness;
it was sweet tea,
nostalgic.
i wore it as a shawl,
i spoke to the water like it was
god, told it my secrets
heard the wind like spirits in the trees
carrying my sins, truth through spores
 in the
 breeze.
swallowed castles,
with my heartaches in the bricks, my ugliness
in the cement and then
i tore them down.
ate new castles,
this time made of rage and wood
i set fire to them.

I stayed up all night
remembering car lights on the highway.
i drew a woman
and she was more beautiful than me
and she
 and she
lives in the pages of sketchbooks,
my wish fulfillment, envy.

I stayed up all night,
thinking of men
and matchsticks (they are both breakable)
and myself
 (i am glass, also breakable).
putting my hands upon keepsakes,
rub my fingers into the juices of sentiment.

i want to bury all the reminders and throw my fear in too.
a casket of bone and dirt,
a casket of fire.

I stayed up all night,
i cried, just tearless weeping,
yelled, just pointless screaming,
begged begged begged
for my heart and mind to break through the barriers
i erected
myself.
and all the secrets i gave to god, the water,
were scattered on the beach for a moment,
the remnants of my makeshift empires,
ruins of shelters i found in me ruins of
scars, dented skin, and at last
at sunrise, i knelt down.
humbled myself in the presence
of my own failure,
so finally finally
finally, the tide came in
and the land was clean.
i was clean.

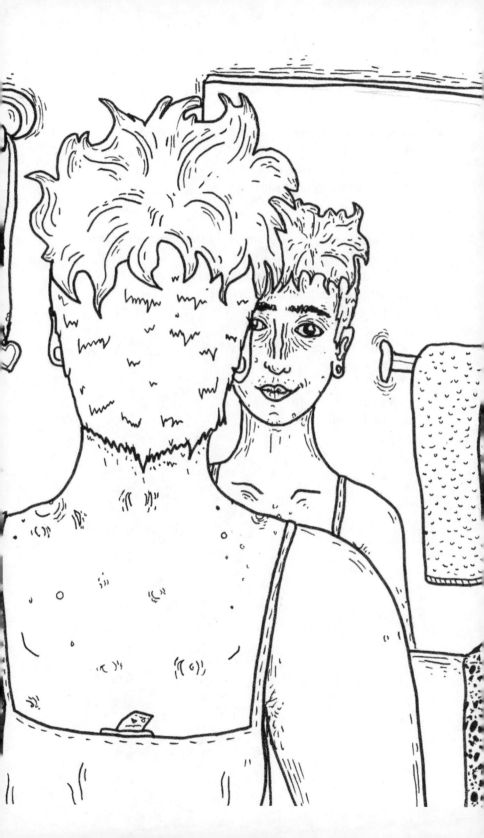

A TRUTH OF MINE

i learned through love
that writing can be reconciliation
as much as it can be revenge that
vengeance could fill the gaps with
gauze and cotton

but healing would fill them with soil to let better things grow
i learned through love
that holding on can make your fingers bleed
and letting go lets your bones breathe
that you could weave the hurt
into a heavy quilt
or be brave enough to shed your skin and
let your truth out

i learned through love
that i am no longer angry
and i'm ready to move on

ACKNOWLEDGEMENTS

I want to thank Jay and Hazel for believing in this project, for giving a first-time author a chance to speak her truths. I want to thank Vivek for nurturing this project, being a brilliant editor so that this book could reach its full potential, and answering every panicked message I sent wondering whether I was good enough. Thank you.

HANA SHAFI is a writer and artist who illustrates under the name Frizz
Kid. Both her visual art and writing frequently explore themes such
as feminism, body politics, racism, and pop culture with an affinity
to horror. A graduate of Ryerson University's Journalism Program,
she has published articles in publications such as *The Walrus, Hazlitt,
This Magazine, Torontoist, Huffington Post,* and has been featured on
Buzzfeed India, Buzzfeed Canada, CBC, Flare Magazine, Mashable,
and *Shameless.* Known on Instagram for her weekly affirmation series,
she is also the recipient of the Women Who Inspire Award, from
the Canadian Council for Muslim Women. Born in Dubai, Shafi's
family immigrated to Mississauga, Ontario in 1996, and she currently
lives and works in Toronto. *It Begins With The Body* is her first book.

Manufactured as the First Edition of
It Begins With the Body in the Fall of 2018
by Book*hug.

Distributed in Canada by the Literary Press Group:
www.lpg.ca

Distributed in the US by Small Press Distribution:
www.spdbooks.org

Shop online at www.bookthug.ca

BOOK
PRODUCTION
WAR ECONOMY
STANDARD

Edited for the press by Vivek Shraya
Type + design by Kate Hargreaves